'This is a refreshing, creative, and pen[...]
seamlessly between photography and [...]
life both literally and metaphorically. It [...] [...]ceptively [...] which
technical knowledge is made accessible and spiritual life made to seem more
possible, but never simplistic. I warmly recommend it to any reader willing to
become more attentive to what surrounds us – and what lies within us.'

Vernon White, Canon Theologian, Westminster Abbey,
and Visiting Professor of Theology, King's College, London

'They say a picture "speaks 1,000 words"! As someone who has researched
visual communications, and enjoys sharing pictures via Instagram and other
social media platforms, I enjoyed this gentle book. The book offers some tech
tips, but is more concerned with the notion of using photography – through
whatever camera or phone – to "see" and experience God in different ways.
There are various thought prompts, themes for reflection, and activities that
should encourage and challenge a wide audience to engage spiritually in
something that is now an everyday activity in a digital age.'

Bex Lewis, Senior Lecturer in Digital Marketing, Manchester Metropolitan
University, and author of *Raising Children in a Digital Age*

'Rather than skim, scan, tweet, and snap our lives, Philip Richter invites all
of us to slow down, to savour, and to see with fresh eyes. In this delightfully
accessible text, each chapter focuses on one aspect of photography, with
simple practical tools and a path to spiritual discovery. Curiosity about how
we frame or reframe images, how camera phones work, and how light and
perspective relate to proportionality leads us in and beyond photography and
deeper into our lives and world. Philip Richter gently guides and accompanies
the reader in understanding the lenses of truth telling and telling stories. He
illumines the importance of knowing the rules, breaking the rules and creating
a rule of life in ordinary and everyday lives.'

Odette Lockwood-Stewart, Director, Community Engaged Learning,
Pacific School of Religion, Berkeley, California

'A book to help you use your phone to see, think, pray – and do. As someone
who often feels disabled by photographic experts, I found it very enabling.'

David Holgate, Canon for Theology and Mission, Manchester Cathedral

'Being aware of how we choose to notice what is around us, and developing our
consciousness of that, is so important for a healthy and self-aware spirituality.

'This is a great little workbook to help you think about how we don't just do photography, but also our life, through various "lenses". It would make a great summer, sabbatical or Lent project, and would be a brilliant gift for any teenager or adult with a camera or camera phone and an inquiring mind.'

Miranda Threlfall-Holmes, Area Dean of Durham,
and author of *The Prayer Experiment Notebook*

'In an age where more people seem to take cameras – in the form of mobile phones – than Bibles to church, Philip Richter gives us permission to integrate these otherwise distracting devices into our spiritual lives. He expands on Dorothea Lange's insight that "the camera is an instrument to see without a camera" by inviting us to consider photography as a spiritual practice that will teach us to see God and our neighbours – indeed ourselves – in new and authentic ways.'

Roman Williams, Executive Officer,
Society for the Scientific Study of Religion

'As a Christian, I believe more and more that everything is spiritual and we can see the divine wherever we look. In *Spirituality in Photography*, Phillip Richter shows us the wonder and beauty of the divine in all things, and how by looking at the world around us and capturing it in photography, we can catch a glimmer of the true beauty and majesty of God.'

James Prescott, author of *Mosaic Of Grace:*
God's Beautiful Reshaping of Our Broken Lives

'Philip Richter offers the reader and inner artist insights into photography techniques and terminology that will be useful for developing your camera skills and your spiritual development, regardless of the kind of photographer that you might be, or even the type of camera you might have. The book leaves ample space for you, the reader, and raises questions for you to explore on your own journey with photography and spirituality.'

The Revd Andy Longe, Methodist minister, photographer and blogger,
www.godlifechurch.me

'Philip Richter has wisely seen the connection between what has traditionally been called "a rule of life" and the art of taking photographs. This relationship between traditional Christian Spirituality and a contemporary art form is most imaginative. His insights can be of assistance to the amateur photographer and the personal quest for meaning in the contemporary environment.'

Brother Patrick Moore, Scholar in Residence, Sarum College, Salisbury

SPIRITUALITY IN PHOTOGRAPHY

Taking pictures with deeper vision

PHILIP J. RICHTER

DARTON·LONGMAN + TODD

First published in Great Britain in 2017 by
Darton, Longman and Todd Ltd
1 Spencer Court
140–142 Wandsworth High Street
London SW18 4JJ

ISBN 978-0-232-53293-7

A catalogue record for this book is available from the British Library

Photos © Philip J. Richter
p.14 Yorkshire Dales stone wall
p.22 Fern
p.55 Raising of Lazarus
p.60 Jewish Ghetto, Venice
p.78 Rose Garden, Mottisfont Abbey

Cover photo ©Stuart Bridewell LRPS, reproduced by permission

Unless otherwise acknowledged, all Scripture quotations
are from the New Revised Standard Version of the Bible.

Designed and produced by Judy Linard

Printed and bound in Great Britain by Bell and Bain Ltd, Glasgow

'What seest thou else?'
(Prospero to Miranda, *The Tempest*, Act 1, Scene 2,
William Shakespeare)

'The contemplation of things as they are without
substitution or imposture without error or confusion is in
itself a nobler thing than a whole harvest of invention.'
(Francis Bacon 1561–1626 – lines attached to the
darkroom door of photographer, Dorothea Lange)

'Stop *looking* and … begin *seeing*! Because looking means
that you already have something in mind for your eye to
find; you've set out in search of your desired object and
have closed off everything else presenting itself along the
way. But seeing is being open and receptive to what comes
to the eye.'
(Thomas Merton, cited in Ron Seitz, *Song for Nobody*)

'There lives the dearest freshness deep down things …'
(Gerard Manley Hopkins, 'God's Grandeur')

CONTENTS

INTRODUCTION AND INVITATION

Millions of photos are taken every day across the world. Some are just snapshots. Others are more carefully crafted and, as they are made and viewed, have the capacity to deepen our vision and sharpen our sense of what life is all about. We will be exploring how our photography and our spirituality can inspire each other. We will be discovering how photography can offer unique perspectives on ourselves, our world and our faith – as we focus on some particular aspects of photography and give some ideas for hands-on experience with your camera.

You won't need any prior experience or expertise – just some enthusiasm to explore how photography might deepen your spirituality (and vice versa!). You will need a camera of some sort – anything from a camera phone to a high-end camera. We will be honing up our photographic skills a little, but the accent will not be on producing technically perfect images. The idea is to create some images that help you express yourself spiritually and that might potentially be a spiritual resource for others too. We will aim to open our eyes, through the camera, to God's presence in ordinary as well as special places.

Unlike conventional camera clubs and 'how to' books this will not just be about developing your photographic

skills. Just taking technically proficient photos can eventually become a rather soulless activity, overlooking key points, such as: Why are you taking photos in the first place? What has caught your attention and moved you? But, equally, this will not just be about sharpening your spirituality. If you are consistently disappointed by your photos, you may need some technical tips to help you express yourself more fully through them.

These resources are for amateur photographers and for amateurs interested in spirituality. By 'amateur' we mean people who do something for the love of it – the word comes from the Latin *amator* (lover). Amateurs may or may not be especially good at what they do, but they definitely enjoy doing it. These resources are designed for people with a growing love for photography – much like the celebrated Victorian photographic pioneer, Julia Margaret Cameron, who wrote: 'From the first moment I handled my lens with a tender ardour, and it has become to me as a living thing, with voice and memory and creative vigour'.[1] Those might not quite be the words you would use to express your love for photography, but the hope is that you too are energised when you are out taking pictures.

The poet-priest, George Herbert (1593–1633), once wrote:

> A man that looks on glass,
> On it may stay his eye;
> Or if he pleaseth, through it pass,
> And then the heav'n espy.[2]

He was writing well before the invention of photography, but these lines could equally apply to ourselves and the camera. When he referred to 'glass', it is possible that George Herbert was referring to an early telescope.[3] We can choose to focus on our camera and all its gadgets or we can, instead, choose to use our camera as something to freshen and deepen our vision.

Each chapter highlights a different aspect of photography, offering some practical ideas and then drawing out some potential connections with spirituality. You are invited to take plenty of time to explore each of these aspects – perhaps up to a month. Each chapter includes a 'challenge' – some photographic and spirituality projects to try out – and at the end of each there is a section laid out as a journal, with space for your own photos and reflections.

You may get the most out of these resources by inviting a few other like-minded photography 'amateurs' to form a camera group. Unlike most camera clubs, the accent wouldn't be on technical excellence but on taking and sharing your photos on the month's particular 'challenge'. You could share with the group what you saw and felt when taking and reviewing the pictures. Also, since a photo takes on a life of its own – once it is taken and shared – and can become a spiritual resource for others to share, other members of the group could discuss what they see and feel in your pictures. That way you could motivate and inspire each other. It could also be a non-threatening way of exploring aspects of spirituality with people who 'don't do religion'. Spirituality can be defined as 'lifestyles and practices that embody a vision

of how the human spirit can achieve its full potential'[4] – for some people this can be part of their religion, for others it is something that doesn't necessarily involve religion.

Some of you will be using a camera phone as your main camera. The great advantage of this is that it will always be with you, so your photography can be more spontaneous. There are boxes included with specific advice for camera phone users in each chapter of the book. We have found these tips useful, but they may not be applicable to every camera phone – if in doubt please always consult your manual. The products, applications and services mentioned are for illustration purposes only. While reasonable care has been taken, no assurances should be implied as to their quality.

We invite you now to let your camera take you on a journey of discovery, as you let your photography and your spirituality inspire each other.

SPIRITUALITY IN PHOTOGRAPHY

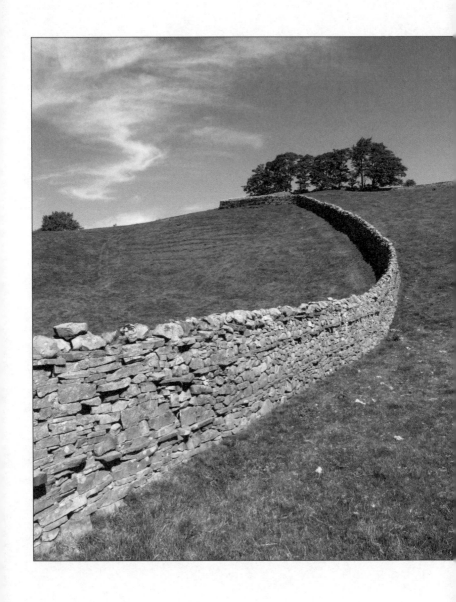

FROM SNAPS TO SLOW PHOTOGRAPHY

It's easy to take lots and lots of photos with today's digital cameras. Years ago, you had to be more careful what you took, when you had to keep putting expensive rolls of film in your camera. Some people are snap-happy. At tourist sites you may see them 'hoovering' up the scene with their camera – taking pictures of anything and everything, before jumping back in their car or coach. Little thought goes into this kind of photography and, not surprisingly, when the pictures are reviewed later they can be quite disappointing – 'That's not how I remembered it!' they say to themselves. Sometimes the snap-happy behave almost like hunters, intent on capturing their images, grabbing their photographic prey. This predatory approach to photography even carries over into some of the language we use: photoshoots, image capture, taking a photo, and so on. The snap-happy can even be quite aggressive to those who get in their way. That sort of photography doesn't sit well with spirituality.

Spirituality relates best to patient, slow photography, which takes the time to stop and look, to wind down and be truly present, to see with the 'eyes of your heart',[1] to 'receive' or 'make' a picture, rather than 'take' it. One way of cultivating a slower approach to photography is to limit yourself to, say, thirty six images a day (as if you were still

using a film camera) – that way you find yourself taking more care over each one, rather than shooting mindlessly everything you see. Another way is to put your camera away for, say, thirty minutes when you arrive at a tourist site or somewhere else you'll be photographing. Begin by just using your eyes. Look around you and move to different vantage points, seeing things from different perspectives. See where your attention is drawn. Where is the energy in the scene? What is moving you? What is beautiful in the scene? What is comical? What is majestic? What is awesome? What is melancholic? What personal associations has this scene for you? Only then will you begin to have a sense of what you want to convey in your photo – and the chances are that you will make a photo that is far more meaningful than a casual snap taken by a tourist.

Another way of cultivating a slower approach to photography is again to put away your camera at first and, this time, pick up paper and pencil and start drawing what you see. You don't need to be a good artist at all, as the drawing is not intended to be shared. It's just a way of helping you spend time actually looking intently at your surroundings. Then, after you have been drawing for at least half-an-hour, pick up your camera again. By now you will probably have a much better sense of what you want to photograph in this time and place and what will be the centre of attention. In the autumn of 2015 the Rijksmuseum art gallery in Amsterdam invited its visitors to put away their cameras and start drawing: 'The problem now is … that we look at things quickly, fleetingly, superficially. We are easily distracted: by other people, our own thoughts, a little device vibrating in an inside pocket.

Wouldn't it be nice if we could look a bit closer, a bit better. Maybe we have to learn how to look. The good news is, we can. It is not difficult, and everyone can do it: by drawing!'[2] You see more when you draw, even if you don't reckon to draw very well. Of course the word 'photography' comes from the Greek words *photos* (φοτος), meaning 'light', and *graphos* (γραφος), meaning 'writing' or 'drawing', so maybe there is something rather appropriate about drawing with a pencil before 'drawing with light'.

The Japanese spiritual writer, Kosuke Koyama, used to recommend his readers to discover ways of slowing their lives down to '3 mph', metaphorically, if they wanted to reconnect with their true selves. He claimed: 'God walks "slowly" because he is love. If he is not love he would have gone much faster. Love has its speed. It is an inner speed. It is a spiritual speed. It is a different kind of speed from the technological speed to which we are accustomed. It is "slow" yet it is lord over all other speeds since it is the speed of love. It goes on in the depth of our life, whether we notice or not, whether we are currently hit by storm or not, at three miles an hour. It is the speed we walk and therefore it is the speed the love of God walks.'[3] A '3 mph' approach to photography can help cultivate a slower, more measured take on everyday life – and vice versa.

A famous story is told about two sisters in Luke's Gospel: 'Now as they went on their way, he (Jesus) entered a certain village, where a woman named Martha welcomed him into her home. She had a sister named Mary, who sat at the Lord's feet and listened to what he was saying. But Martha was distracted by her many

tasks; so she came to him and asked, "Lord, do you not care that my sister has left me to do all the work by myself? Tell her then to help me." But the Lord answered her, "Martha, Martha, you are worried and distracted by many things; there is need of only one thing. Mary has chosen the better part, which will not be taken away from her."[4] There are many layers of meaning in this story, but, on this occasion at least, the two sisters behave very differently and it is said that Mary 'chose the better part'. Mary isn't distracted by frantic activity. She doesn't allow herself to be rushed, but instead completely focuses her attention on her visitor – and perhaps, just maybe, she would have made the better photographer!

As the Welsh priest-poet, R. S. Thomas, once said: 'the meaning is in the waiting'.[5]

 USING YOUR CAMERA PHONE

As well as taking pictures, you can also time things with your camera phone. That offers you a way of timing your initial looking around. Try setting the clock-timer or the alarm to ring in 30 minutes and, in the meantime, put the camera phone away.

Try to limit the number of pictures you take. You might use an app such as Fotr[6] (iOS), which works like an old fashioned film camera. You pay for a 'digital film' of 24 or 36 frames and, once you have taken that number of images, your photos are printed out and posted to you.

Your challenge

Make your photos more slowly. Limit yourself to a maximum of 36 per day.

Consciously slow down your life. Refuse to be rushed. Discover the single thing that matters.

My challenge notes

New discoveries about my photography …

New discoveries about myself and my spirituality …

Things to explore more …

What I will try differently in future …

My photo that best expresses my journey of discovery in this chapter...

You are invited to
print out one of your photos
and place it here

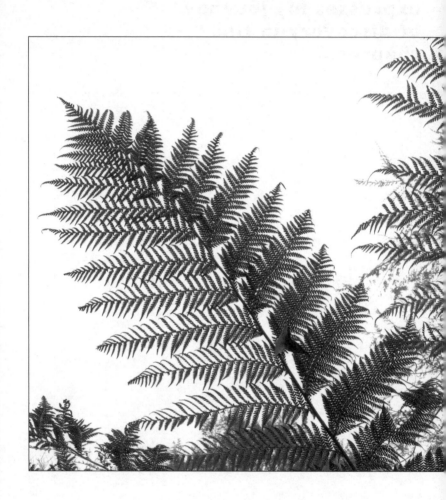

FRAMING

When we take a photo we group together part of the rich reality that surrounds us in a frame. We include some things and exclude others from the immensity of visual data we are exposed to, unless we take a fully 360 degree image with a special camera or app, for instance. Depending on what kind of lens we have and whether it is zoomed in or out, we can include more or less of our surroundings. It's worth looking carefully at what you are including in the frame, before pressing the shutter. Otherwise you may find you have captured something different than you intended. Ideally, look through your camera's viewfinder if you have one. LCD panels on cameras and smartphones can be quite difficult to see in strong light. You might also try making a frame by holding your fingers and thumbs at right angles, to experiment with different views before using your camera.

Of course, photos can always be cropped afterwards, using software such as Photoshop[1] or the 'Snapseed'[2] app (iOS or Android), if you are unhappy with how the picture is framed. You may, for instance, sometimes choose to lop off part of the subject in order to stimulate a sense of mystery and fascination about what lies beyond the edge of the frame. Or you may want to create an interesting shape between the edges of your subject and the edge

of the frame. Much more of a problem, however, is what you unintentionally miss out of a frame when you take the original photo. So, it's worth looking carefully at what lies beyond the edges of your photo when you are preparing to take it – in case you need to step back or zoom out to include more. Try slowly looking around the edge of the frame clockwise and then anti-clockwise. Sometimes it's difficult to understand an image without seeing its context, so try not to crop too much of the surroundings. If in doubt always increase what's in the frame – it can always be cropped later. If you are including people in your image, it's always worth checking for unintended distractions in the frame – scrutinise the background carefully to make sure that, for instance, an individual doesn't appear to have a lamppost growing out of their head!

You will need to decide how much you want to include in the frame. Will it be a busy, crowded and complex image or will it be a relatively uncluttered and simple image? It will partly depend on whether or not you intend to print it out and, if so, at what size. Simpler images tend to work better if you envisage a small print. They will also communicate better with people who are not necessarily particularly visually aware – people who tend to respond more strongly to words or sounds, for example. More complex images tend to work better when seen on a large screen or when printed out relatively large. These photos tend to absorb people's attention more. You can't always fully understand them at first glance and your eyes linger on the image much longer. Complexity, if it arouses people's fascination and

does not merely confuse, can help make the difference between a snapshot and a meaningful photo. However, too much busyness and complexity may distract the viewer. Ask yourself what captured your attention and whether or not that is clearly conveyed in the photo.

Photography can be an effective way of helping us bracket out much of what surrounds us, in order to concentrate on what we choose to include in the frame. Framing both reveals and conceals. It draws attention to what you include, intentionally or intuitively, within the frame and hides from the viewer of the photo what is not included in the frame. It is worth reflecting on what you regularly tend to include and exclude when framing. It may give you extra insight into what you most value in your life, and, therefore, habitually include in the frame. Conversely, you may find yourself regularly excluding from the frame particular things and people, and even aspects of yourself, that you tend to shy away from. To what extent are you allowing your gaze to be narrowed so that you overlook things of real interest, beauty, and value? Photography might help offer a glimpse into how, in your personal life, you might be settling for a cosy, complacent, over-familiar way of life, rather than daring to opt for a more real and challenging existence, 'outside the box', as it were. Perhaps your photography highlights aspects of your life that you don't particularly want to confront. For instance, if all your images are calm and fluffy and pretty, maybe this could be because you might be bracketing out your own inner turmoils, jagged edges, and incompleteness. Sometimes it's important to extend our gaze beyond our favourite frames of reference.

We can easily overlook people whom we don't value. Our society and media tell us that some people are more valuable, while others are, for instance, scroungers or troublemakers. But often the marginalised, those outside the frame, bring us closest to the meaning of life. Jesus claimed: 'Blessed are you who are poor, for yours is the kingdom of God.'[3] The New Testament describes how Peter and John encountered a physically disabled man by the 'Beautiful Gate' in Jerusalem, who was each day carried to the gate to beg. Rather than passing by and ignoring him, it is said that they both 'looked intently' at him, spoke with him and then healed him. Peter and John deliberately included him in their frame.[4] Imagine if you had been there, with a camera – might you have been tempted simply to photograph the famous gate or to Photoshop the beggar out of the image afterwards?

Sometimes we need to re-frame the communities we belong to, especially if we begin to think of them in cynical or despairing terms, otherwise we may promote a spiral of decline. Keen photographer and Methodist presbyter, David Perry, points out that, in society at large, his Church is associated with 'a story of decline and dwindling numbers'. But, he says, 'look closely ... and you can see something altogether different'. So he encourages the Church to 'reframe the narrative' with pictures of the Church 'that are remarkably inspiring and hopeful'.[5] The exciting thing is that, by experimenting with the frames that we use to understand ourselves and the world around us, we can expand our gaze and begin to see all kinds of things previously hidden or overlooked.

 USING YOUR CAMERA PHONE

Unlike some digital cameras, your phone won't have a viewfinder to look through. You will be relying on a relatively small LCD screen. This will show you how your pictures will look as quite small images. You may at this stage want to consider whether it would, or would not, work as a larger image, for printing out or viewing on a bigger screen.

It can be difficult to see the LCD screen in bright sunlight. You can buy specially designed sun-shield hoods. Alternatively, just try cupping your hand around the screen or shading it with a piece of dark card.

Your camera phone will have the facility to zoom in on your subject, but it's worth being cautious about using this. Many camera phones have a 'digital', rather than 'optical' zoom. The phone's software simply magnifies a part of the overall digital image. This means that the picture quality and resolution of your zoomed image may be disappointingly low. Some camera phones, such as the iPhone 7 Plus, overcome this problem by having 'optical zoom' – an extra telephoto lens. You can also buy clip-on or stick-on telephoto lens attachments for other camera phones. However, if you are just relying on 'digital' zoom, why not simply walk closer to your subject, if you can?

If you want to maximise the area from which you will make the final crop of your picture, you could try taking panoramic photos. This may already be a camera option or, alternatively, you may need a separate app. Hold your camera phone vertically and turn it steadily as you take the picture, keeping the image completely level, to get the best panorama.

Your challenge

Try cropping some of your old photos and experiment when taking new photos – include less or more than usual in the frame.

Become more aware of what and who you overlook. How might you need to reframe your gaze and your values?

My challenge notes

New discoveries about my photography …

New discoveries about myself and my spirituality …

Things to explore more …

What I will try differently in future …

My photo that best expresses my journey of discovery in this chapter ...

You are invited to
print out one of your photos
and place it here

SUNRISE

P hotos of dawn and sunrise are much rarer than photos taken at the other end of the day, for the simple reason that photos at the beginning of the day take much more planning and self-discipline. The alarm needs to be set early (especially in the summer) and you need to be ready to photograph just as it gets light. If you are a lark, this shouldn't be a problem. If you are an owl, try making the effort to be up at this magical time. Photographers call this the 'golden hours' – starting just before sunrise and finishing just after sunset – because of the unique quality of light at these times.

You may need a tripod, a very steady hand or to rest your camera on something firm, because there will inevitably be a limited amount of light. If you are trying to capture a beautiful sunrise, you may need to darken your overall image, if your camera lets you do that, especially if you are including a dark foreground. Otherwise your camera may try to lighten the foreground and over-expose the image, washing out your beautiful sunrise. Some cameras will let you fix the exposure by half-clicking on the shutter button – if so, point your camera at the sky, fix the exposure, gently lower the camera, and then take the picture. On an iPhone or iPad you can tap on the sky and, if necessary, brush your finger downwards to darken it. It's certainly worth including

things in the foreground, to help give depth to the image and to indicate where the photo is being taken, but these will probably just show up as silhouettes in a sunrise, or sunset, picture. Your camera may have trouble auto-focusing in low light, so, if you can, manually set the exposure to 'infinity' ∞.

Look especially for the things most associated with dawn and less visible at other times of day: early morning mist, as it starts to lift; dew drops on foliage; low sun and long shadows; empty places, with no, or very few, people (this could, for instance, be a deserted beach or the heart of a big city, before it comes to life).

Photography gives you an excuse to be there at that time of day and, if all goes well, offers you an image to meditate on afterwards. Try not to worry too much about the technicalities of making the photo. Just enjoy being there at this unique dawn, opening up a brand new day with huge potential. The light changes very rapidly so it will be important to be fully present, without your mind being distracted by the day ahead or the practicalities of the photo shoot. Otherwise you may miss what is unfolding around you. One way of noticing what is actually there is to close your eyes for a few seconds and then re-open them, to help refresh your view and find out what really draws your attention. As your eyes look around the scene, where do they come back to and rest? Being fully present is a really useful spiritual habit to carry over into the rest of the day.

For many people, dawn, when it is no longer night but not quite day, is a time when they glimpse something of God's mystery and wonder. The new day is a time of

infinite possibility and doesn't need to be a repeat of yesterday. Your early morning photography may be able to capture and convey some of that sense of freshness and new hope. You may like to reflect on some of the following quotes, from spiritually aware people for whom the dawn was something very special.

'But the path of the righteous is like the light of dawn, which shines brighter and brighter until full day.'[1]

'One who rules over people justly, ruling in the fear of God, is like the light of morning, like the sun rising on a cloudless morning, gleaming from the rain on the grassy land.'[2]

Jesus said 'When it is evening, you say, "It will be fair weather, for the sky is red." And in the morning, "It will be stormy today, for the sky is red and threatening." You know how to interpret the appearance of the sky, but you cannot interpret the signs of the times.'[3]

'Your enjoyment of the world is never right till every morning you awake in Heaven; see yourself in your Father's Palace; and look upon the skies, the earth, and the air, as Celestial Joys: having such a reverend esteem of all, as if you were among the Angels.'[4]

'New every morning is the love
our wakening and uprising prove;
through sleep and darkness safely brought,
restored to life and power and thought.'[5]

'Sweet the rain's new fall, sunlit from heaven
Like the first dewfall, on the first grass.'[6]

'Rabbi Pinchas asked his students how one recognises the moment when night ends and day begins. "Is it the moment that it is light enough to tell a dog from a sheep?" one of the pupils asked. "No," the rabbi answered. "Is it the moment when we can tell a date palm from a fig tree?" the second asked. "No, that's not it, either," the rabbi replied." "So when does morning come, then?" the pupils asked. "It's the moment when we look into the face of any person and recognise them as our brother or sister," Rabbi Pinchas said. "Until we're able to do that, it's still night."'[7]

 USING YOUR CAMERA PHONE
Image stabilisation is now built into some camera phones, but most will struggle to take sharp pictures in low light conditions, unless you keep the device absolutely still. If the camera phone is hand-held, try taking and holding a deep breath, keeping your legs apart, and bringing your elbows into your body before taking the picture. If possible, use a tripod. Special clamps can be bought to fix the camera phone to a full-size or mini tripod, or you can get an all-in-one device, such as the flexible 'Joby Grip Tight GorillaPod Stand'.[8]

Tapping the LCD screen to take pictures can cause camera-shake. See if there are other gentler methods of releasing the shutter, such as a side-button (though on some devices the picture is not taken until you press and *release* the button). You may be able to totally avoid touching the camera by using the inline volume control on a headphone cable or a Bluetooth wireless shutter trigger, such as those built into selfie sticks. Alternatively, you could use the self-timer function on your camera phone, which delays the shutter by, say, three or ten seconds after you press it.

Your camera phone's automatic exposure and focus may be stumped by sunrise or sunset. You may need to tell it what to expose for, by tapping on the sky. Then you may need to fine tune the overall exposure. On the iPhone, for instance, after you have tapped the screen, you can brush your finger up or down to increase or decrease the brightness. Your camera phone may struggle to focus in low light conditions. You might like to consider using an app to gain full manual control of your camera phone, such as 'Manual'[9] (iOS) or 'Camera FV-5'[10] (Android). This will enable you to manually adjust such things as focus and shutter speed. It will also allow you to choose a low ISO setting, to minimise grainy 'noise' in the image when photographing in these conditions.

There is a wide range of contrast in sunsets and sunrises. They contain very dark and very bright areas. High Dynamic Range (HDR) photography works well in such contexts and helps to bring out details that otherwise would be over- or under-exposed. HDR may already be an option on your camera or you may need to install an app, such as 'True HDR'[11] (iOS) or 'HDR Camera'[12] (Android), which will also give you greater control over the HDR image. Try taking the picture with and without HDR and see which you prefer.

If you are not quite sure when and where sunrise and sunset will be on a given day, there are apps out there to help you, such as 'The Sun – Rise and Fall'[13] (iOS). There are also apps available to help you find the time of the 'golden hour' at any location on any day, such as 'Golden Hour'[14] (iOS and Android).

Your challenge

Get up early and photograph the sunrise. Try to be alert to what is unfolding around you.

Enjoy the freshness of each new day. Allow yourself to be fully present during the sunrise and the rest of the day.

My challenge notes

New discoveries about my photography …

New discoveries about myself and my spirituality …

Things to explore more …

What I will try differently in future …

My photo that best expresses my journey of discovery in this chapter ...

You are invited to
print out one of your photos
and place it here

PERSPECTIVE

The greater the sense of perspective and depth in a photo, the more it will seem real to the person viewing it. It may even draw the viewer into the image, as it were, and let them feel immersed in the picture, as if they are actually there, taking part. Perspective gives an impression of increasing depth, from objects in the foreground to objects on a distant horizon. Even though we know that a photo is a flat image on paper or a screen, good perspective can make it appear 3D.

Perspective can be enhanced in your photos in various ways. One way is to let distant things be out of focus and indistinct. You can do this by focusing on something close to your camera – blurring of the background will be accentuated if you can use a large aperture, which, rather confusingly, means choosing the *lowest* numerical value for the aperture setting. Another way of achieving this effect is to deliberately choose a scene in which there is a haze in the far distance. This is called 'aerial' or 'atmospheric' perspective. The distant haze will often appear to have a blue tint. This will not necessarily be a fault in the photo – it's simply that tones soften and turn bluer the further away that objects are. Another way of introducing a sense of perspective is by including lines in the photo that appear to converge towards one or more points, as they get further away from the camera. These

lines could be, for instance, the edges of roads, floor tiles, the top and base of walls or windows, or lines of trees, angled inwards.

Since the Renaissance, artists became adept at depicting this form of 'linear' perspective – see, for example, Carlo Crivelli's painting of 'The Annunciation, with Saint Emidius'[1] in the National Gallery. It is thought that some artists, for example, Vermeer and Canaletto, may have used a forerunner of the modern camera, such as the 'camera obscura' or 'camera lucida', to help depict perspective. Fortunately, you have the optics of your camera to help you. However, it's worth avoiding using a telephoto lens or a zoom lens 'zoomed in', as this will tend to decrease the sense of linear perspective. Also, it's important to select the right vantage point – if you are too low down to the ground or too high your photo may not successfully highlight the convergence of lines.

Another way of accentuating perspective is to include a number of similar easily recognisable objects going away from the camera, such as a set of trees or telegraph poles, or people at different distances. Although we know that, say, telegraph poles are in fact almost identical in height, they will appear smaller the further they are from the camera and this will give a sense of depth to your photo, thanks to what is termed 'diminishing' perspective. Another thing you could try in order to enhance a sense of perspective in your photos is to position objects with warmer colours (for example, red, yellow or brown) towards the foreground and objects with cooler colours (for example, blue, green or violet) in the background. Warmer colours tend to be perceived as coming out of

pictures towards the viewer, and to be more 'in your face', as it were, whereas cooler colours appear to recede from the viewer. You can take advantage of 'colour' perspective by, for instance, positioning an orange subject in front of a green background and, thereby, adding depth to your image.

Getting things properly in perspective in our own personal lives is an important aspect of our spirituality. It's easy to start getting things out of proportion and to be dominated by anxiety about things that we allow to loom large, but which are really quite insignificant in terms of what really matters. Our lives can become consumed by such things as ambition or materialism or pleasure and these can take a larger part in our lives than our family or the beliefs or values that we claim to hold most dear. Such things can become 'gods' or idols that take the place of God and start to put everything out of perspective in our lives. Jesus warned: 'where your treasure is, there your heart will be also'.[2] Sometimes people can get things out of proportion because of what they think are excellent reasons. People can be dominated by warped beliefs and ideologies and do things that harm others and bring shame to their fellow believers – this can range from narrow-mindedness and prejudice to acts of terror.

One of the tricks for maintaining a sense of perspective in our life is to review our decisions, our plans and our actions in the light of God's spacious, gracious and liberating kingdom. How different might things look *sub specie aeternitatis* – in the light of eternity – and in relation to God' s perspective that encompasses

all space and time? As the hymnwriter, Timothy Rees, puts it: 'God is Love, so Love for ever o'er the universe must reign.'[3] At the very least, it might make us less impatient and more confident that 'God is working his purpose out, as year succeeds to year.'[4]

One of the reasons why we lose a sense of perspective is that we are not always good at managing our time. Attending to perspective in our photography can help remind us that not everything is immediately in front of us – some things belong to the far distance. Imagine walking into your picture – it might take some time to arrive at the middle-distance and then eventually the horizon. Sometimes, when we begin to be stressed about the sheer busyness of our lives, it would be good to spend time splitting our 'to do' list into things that must be attended to now, as a matter of urgency, things that can be done in the near future, and things that can safely wait for a more distant future – things we must keep on our horizon, but which do not need immediate attention. That can help to get things in proportion and make life manageable again.

Good perspective in a photo can help to immerse the viewer in the image and make them feel they are part of the action. Our spirituality also invites our full involvement. In today's culture it is easy to become consumers and spectators, rather than full participants. But when we have a true sense of perspective in our lives we are likely to be fully committed to the things of God's kingdom, and not just watching from the sidelines.

 USING YOUR CAMERA PHONE
One advantage of using a camera phone is that it's lightweight and portable. This makes it easier to try out different vantage points. You can easily hold it at different heights and at awkward angles, although sometimes it may be difficult then to see the screen and you may need to take a series of images until you're satisfied with the result.

If at all possible, avoid using zoom, for the reasons outlined previously (in 'Framing') and to avoid flat images with less sense of perspective.

The lenses of most camera phones will not produce images with what is termed a small 'depth of field', with the foreground in focus and the background nicely blurred (the latter is sometimes called 'bokeh'). This means of achieving a sense of perspective in your photos is not yet widely available on camera phones. There is a fake, digitally produced background blur effect available in 'Portrait' mode on the iPhone 7 Plus. Also, the 'After Focus'[5] app (iOS and Android) applies a background blur effect once you select the focus area or take a 'double photo' from which it automatically recognises the nearest object.

Another way of introducing a sense of depth into a photo is to do some 3D photography with your camera phone, although you will need a

special viewer or special glasses to see the images in 3D. Try using an app such as '3D Camera'[6] (iOS) – this involves taking two photos, a few inches apart, and then the app software creates different types of 3D images. Alternatively you could use a lens attachment such as 'Kúla Bebe'[7] – this involves taking just one image, so is best for scenes that include moving objects. 3D images can give viewers a good sense of immersion in the photo.

Your challenge:

Try out some of the ideas for increasing a sense of perspective in your photos.

Review your 'to do' list. Discern what needs to be done immediately, what can be done in the near future and what can safely be left till later.

My challenge notes

New discoveries about my photography …

New discoveries about myself and my spirituality …

Things to explore more …

What I will try differently in future …

My photo that best expresses my journey of discovery in this chapter ...

You are invited to
print out one of your photos
and place it here

TELLING A STORY

Some photos tell a story. Not every subject or photography genre lends itself to story telling, but photos often become more engaging and dynamic when they tell a story. Often a story is told in a sequence of images, or photo story, but sometimes all you need is a single image – and that's what we shall focus on here. For instance, Dorothea Lange was commissioned to take photos of the rural poor during the American Great Depression. Her 1936 image of a hungry migrant mother on a pea-picker camp, in a lean-to tent, with her children tightly huddled around her, became one of the most famous and influential news photographs ever.[1] This image of extreme poverty stimulated a public outcry and, almost immediately, the release of 20,000 lb of food aid to the camp by the Federal Government.

Another single image that told a powerful story was 'Hands' by the American photographer, Paul Strand. The photo was taken on the remote island of South Uist, in the Outer Hebrides, in 1954. Guardian journalist, Sean O'Hagan, has commented: 'It's a portrait ... he's condensing all the ideas of community and struggle and heroic stoicism into this one image of these extraordinary old and battered hands ...

almost a landscape of hard work, old age, toil, struggle, survival.'[2]

Journalism usually relies on a single image to help tell a story. Try getting some ideas from prize-winning images, such as the World Press Photo contest winners.[3] The key ingredients of a journalistic story are summed up in some words from a poem by Rudyard Kipling:

> 'I keep six honest serving-men
> (They taught me all I knew);
> Their names are What and Why and When
> And How and Where and Who ...'[4]

Of course, these six pieces of information will not always be self-evident in any one photo. Sometimes it may be important to caption the image to help the viewer understand. For instance, a photo of men collecting up stones in a war torn area may be depicting them picking up stones to attack their enemies or, alternatively, may be depicting them starting to clear up debris after conflict – sometimes only a caption can interpret what is actually happening.

For photos to tell a story, they must, first and foremost, grab attention and excite the viewer's curiosity. Good stories not only tell a narrative, but also convey ideas, mood and emotion. It's important to set your subject in context and not to crop the image too tightly. It's also worth showing your subject interacting with other people. The photo doesn't necessarily have to tell the entire story; nor does the story need to

be self-evident as soon as one glances at the image. In fact, the picture may become cluttered if it tries to include everything. Better to let the viewer take time in discovering what the picture is about.

Californian photographer, Dan Eitreim, has devised a simple method for introducing storytelling into photography: get into the habit of looking around you and asking, 'If I had to take only one picture of this, what would be the ideal way to communicate exactly what is happening?'; and then ask, 'What is the least I could show that would clearly indicate what is happening?'[5] This method helps you discover the defining image and then remove any unnecessary details.

Sometimes you may tell a story about yourself in a photo. Perhaps to affirm something in your life or to address an aspect of yourself that might need to change. The House of the Resurrection at Mirfield published a picture meditation called 'Monday Morning' (c. 1980). The card opened to a picture of a busy, somewhat disorganised desk and the accompanying meditation included these words: 'Sometimes I wonder if only *some* of the work is absolutely necessary, and comes from God, and whether the rest of it I have taken on just to prove that I am occupied in important business'. You may have stories to tell in your own photos about the preoccupations and directions of your life.

The camera may also help us see Bible stories differently. Surprising though it sounds, photography can potentially be used to free our imagination and gain new perspectives on Scripture. Let's explore one particular method: photographing life-size and miniature biblical tableaux.

Julia Margaret Cameron was one of the most famous pioneers of photography. As well as taking accomplished photographic portraits of the rich and famous in Victorian England, she also staged photographic tableaux conjuring up scenes from mythology, famous works of literature and the Bible. This was partly to demonstrate that photography could emulate fine art, but it also enabled the viewers and photographic subjects to, as it were, enter into a Biblical narrative and bring it to life. However, photographic tableaux of biblical scenes soon dropped out of fashion – as one commentator has put it: it has long been recognised that 'the realism of the medium inevitably reduces the sublime to the ridiculous'.[6] Take a look at Julia Margaret Cameron's soft-focus photographs of 'The Three Marys' and 'The Angel at the Tomb' and see if you agree or disagree.[7]

In 2008, photographer, Dennis Morris (famed for his pictures of Bob Marley), parish priest, Bob Mayo, and youth worker, Ben Bell, worked with young people from Islington to re-present images of the Easter Story – translating it 'into the lives of children and young people today'.[8] The Crucifixion, for instance, was powerfully depicted as a young man hanging on a wire fence. 'I wanted to give a spontaneous feel and quality to each photo,' explained the photographer. 'I focused on ensuring that each of them looked like it wasn't too set or staged. I was going for a snapshot feel, immediacy, capturing a moment in time.' The parish priest noted that he and the youth worker 'had our own understanding of how the events should

be pictured but we needed to give the story away in order to get it back reshaped and re-invigorated through these pictures.'[9]

The genre of biblical photographic tableaux has also been intriguingly revived by artist, Joachim Froese, who, in an exhibition in 2005 called 'Species',[10] displayed black and white photographs of his daughter's discarded toy figures re-enacting famous scenes from the Bible, such as 'The Last Supper', 'The Judas Kiss' and even 'The Resurrection', with sugar cubes creating an architectural setting. His photographs are reconstructions of famous biblically themed Renaissance frescos. According to Australian art critic, Madeleine Hinchy, his use of black and white photography 'creates a sense of witness, or the idea that these events actually happened' and 'there is a sense of acute characterisation and emotion that is uncanny.'[11]

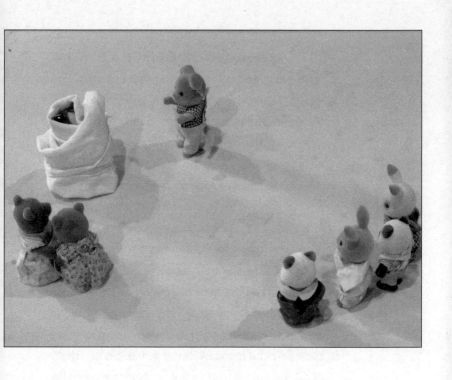

 USING YOUR CAMERA PHONE
To add captions to your photos you could use an app such as 'After Photo'[12] (Android and iOS) or 'Font Candy'[13] (iOS and Windows Phone). Alternatively, if you use the Instagram[14] app (iOS and Android), you will have the option to add a caption once you have applied a filter. You will have a choice of different fonts, font sizes and colours. The purpose of a caption is to help the viewer understand the photo, so usually it's best not to let the caption dominate the image and become the centre of attention.

You might like to tell the story of a year in your life, with a photo for each day. There are apps that can facilitate this, such as 'Photo 365'[15] (iOS) or '365 Photo App!'[16] (Android). Equally, you could use a web browser on your camera phone to upload to '365 Project'.[17]

Your challenge

Reflect on some photos
in newspapers or online news media: what
makes these images effective or not effective?
Try taking some photos that intentionally tell a story in
a single image. Ask someone else to view your images
and find out what they see in them.

Try telling some stories about
yourself in your own photos – what are the directions
and preoccupations of your life? Try devising and shooting a
biblical photographic tableau of your own:

- Get some helpers
- Choose a Bible story
- Devise how you will stage it
- Get a volunteer to be the photographer (or use the self-timer)
- Position yourselves in the tableau

- Take the photograph – but (and this is important) stay still for 20 seconds – early cameras had a long exposure time!
- Review the image together – what, if anything, does this image add to your appreciation of this Bible passage?

Try making a miniature biblical photographic tableau of your own:

- Get some helpers
- Choose a Bible story
- Devise how you will stage it
- Position the miniature figures (e.g. from Sylvanian Families) in the tableau

- Take the photograph
- Review the image together – what, if anything, does this image add to your appreciation of this passage?

My challenge notes

New discoveries about my photography ...

New discoveries about myself and my spirituality ...

Things to explore more ...

What I will try differently in future ...

My photo that best expresses my journey of discovery in this chapter ...

You are invited to
print out one of your photos
and place it here

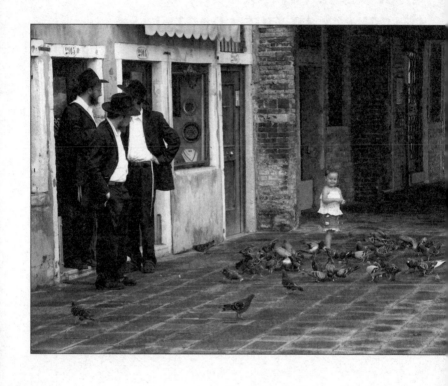

MIST AND FOG

Sometimes you may find yourself photographing in mist or fog, either because these happen to be the weather conditions or because you have deliberately decided to experiment with taking photos in these conditions. Images taken in mist or fog can be very evocative. Depending on your subject and the way you compose your photo, the image may evoke such moods as serenity, mystery, disorientation, fear or uncertainty. Thanks to the effects of the mist or fog, familiar things can look quite unfamiliar. Only things nearby will retain their sharpness. Things in the far distance will be completely invisible. Things in the mid-distance may appear as soft-edged silhouettes, with much reduced texture; forms will be simple and soft and fine detail will not be visible; colours will be muted and tending towards greyness and blueness. This will help things to stand out in the foreground and convey a good impression of depth in your image. Incidentally, mist and fog can also play an important part in conveying depth if they appear in the far distance in photographs of landscapes – this is called 'atmospheric perspective', as we have already seen. Overall, your photo taken in mist or fog will tend to be quite minimalistic and subtle, but all the more evocative because of that, because it will allow freer rein to your creativity and the photo viewer's

imagination. If you print out your picture, you may find that it looks rather washed out. If so, try placing it on a black or dark-charcoal mount – this will significantly lift the image.

Taking photos in mist or fog presents its own special challenges. The automatic exposure meter on your camera is likely to under-expose your image. So, if you can get control over your camera's exposure settings, it is worth deliberately over-exposing your photo in order to capture fully the mood of the misty or foggy scene. It will be important to include some bold and recognisable objects in the misty distance, such as trees or the silhouettes of buildings, and some clearly defined objects in the foreground. Otherwise, if there is nothing to act as a focal point, your photo may just end up as a murky blanket of grey. It can sometimes be very effective to feature something, such as a fence or road or river or line of trees, receding into the mist. This will help to heighten the viewer's sense of curiosity and mystery, as the end point of the feature will be hidden from view. Such features will also function as 'leading lines' to help draw the viewer's eye into what might otherwise be quite a featureless image.

Your camera may find it harder to focus in misty or foggy conditions. It's best to get it to focus on one of your foreground objects, as these need to be more sharply defined. It doesn't matter if the misty background is technically out of focus, as that's the way it's going to look anyhow. You will probably find that the sky is particularly uninteresting in fog or mist and is likely to appear as a featureless block of light grey in your photo.

If possible, it's worth including as little sky as possible, perhaps by taking a higher vantage point and/or pointing your camera downward. The exception would be if you were fortunate to have just the right weather conditions and see a shaft of sunlight coming down through the sky, as the mist begins to clear. The sun needs to be at the right angle and you need just the right amount of water droplets in the air, if you are going to see such a 'sun shaft'. These are also known as a 'finger of God' effect, because, for some people at least, it's as if heaven and earth are touching when they see this phenomenon. It's virtually impossible to plan to see a sun shaft – just be ready to include it in your misty or foggy images if it ever appears.

Foggy and misty weather conditions can speak to us of times of heightened spiritual awareness. There are some traces of this in the Bible. Sometimes, metaphorically, the focus is on mist that quickly vanishes as the sun comes up, for instance: 'I have swept away your transgressions like a cloud, and your sins like mist; return to me, for I have redeemed you';[1] 'Our life will pass away like the traces of a cloud, and be scattered like mist that is chased by the rays of the sun and overcome by its heat'.[2] Elsewhere cloud is used to symbolise the mysterious hidden presence of God, for example: 'Then a cloud overshadowed them, and from the cloud there came a voice, "This is my Son, the Beloved; listen to him!"';[3] 'Then the Lord said to Moses, "I am going to come to you in a dense cloud, in order that the people may hear when I speak with you and so trust you ever after"'.[4]

In some forms of Christian spirituality that dense

dark cloud is understood to be a symbol of our inability as human beings ever to understand God fully, with our limited words, thoughts and images. The more we try to speak of God, paradoxically the less we may feel able to say about God. An anonymous fourteenth-century English Christian mystic coined the term 'the Cloud of Unknowing' to describe this aspect of encounter with God: the willingness to leave behind our inadequate images and holy clichés and rest in the power of God's love.

Eastern Orthodox Bishop Kallistos Ware puts it like this: 'Moses progresses from light into darkness. And so it proves to be for each one who follows the spiritual Way. We go out from the known to the unknown, we advance from light into darkness. We do not simply proceed from the darkness of ignorance into the light of knowledge, but we go from the light of partial knowledge into a greater knowledge which is so much more profound that it can only be described as the "darkness of unknowing" We see that it is not the task of Christianity to provide easy answers to every question, but to make us progressively aware of a mystery. God is not so much the object of our knowledge as the cause of our wonder.'[5]

Taking, and reflecting on, images of mist or fog or low-lying cloud or sun shafts could be a good opportunity to meditate on the awesome mystery of God. It could also be a chance to think about such things as: the wonder of God; the transience of life; a disorientating world; forgiveness; serenity; or the hidden presence of God.

 Using your camera phone

Your camera phone's automatic exposure and focus may be stumped by mist or fog, just as it can be by sunrise and sunset. Much of what we explored previously in 'Sunrise', about how to achieve accurate focus and exposure, also applies to misty or foggy conditions. So, it would be worth revisiting the 'Using your camera phone' box in that chapter (see p. 35); although there is a key difference – in mist or fog your camera phone is likely to under-expose.

Images of mist or fog often look best surrounded by a dark border. You could add a dark border to an image by using a post-production app such as 'Snapseed'[6] (iOS and Android). Alternatively, if you use the Instagram app (iOS and Android), you will have the option to add a border once you have applied a filter.

Your challenge

Try to find some mist or fog or low-lying cloud and take some photos. Or look back at your old pictures of these subjects.

Think about what inspires your wonder and awe. Sense when you are running out of concepts and words. Allow yourself to be drawn into deeper alluring mystery.

My challenge notes

New discoveries about my photography ...

New discoveries about myself and my spirituality ...

Things to explore more ...

What I will try differently in future ...

My photo that best expresses my journey of discovery in this chapter ...

You are invited to
print out one of your photos
and place it here

BREAKING THE RULES

B eginners to photography often want to learn more and join a camera group or start reading around the subject. They soon discover some of the basic rules of photography that help photos look better. For instance, there's the so-called 'Rule of Thirds' – the principle that whatever is the focal point of your photo should be positioned along one of four (imaginary) 'grid-lines' dividing the image into thirds, vertically and horizontally, and ideally positioned at the intersection of two of those grid-lines. If your main subject and the other key elements of the photo are positioned with the help of the 'rule of thirds', this makes for a more dynamic photo. Or there's the rule that a person's eyes should always be sharply in focus. Or the rule that the subject of your photo, if facing sideways, should always have space ahead of them to 'move into'. Or the rule that it is best to have an odd number of subjects in your photo and, ideally, three subjects – as the Latin saying puts it: *omne trium perfectum* (everything that comes in threes is perfect). Or the rule that you should keep the horizon line absolutely straight. Or the rule that you should avoid taking photos in the harsh light of midday.

Many of these 'rules' are essential to composing a good picture. Classical artists have traditionally applied

such rules. Indeed photographers can enhance their own compositional skills by looking carefully at the work of great artists. However, sometimes the rules are there to be intentionally broken. The rules of photography can be followed slavishly and applied dogmatically, but this may produce predictable, rather boring, 'safe' images. Or the rules can be bent or broken to create images that stand out from the crowd. As the Norwegian photographic writer, Haje Jan Kamps, put it: 'if it is "wrong", but gives a beautiful result, it ain't wrong'.[1]

Lightroom cropping overlays

The 'rule of thirds' sometimes pleads to be broken: a strongly symmetrical subject is best centred in your photo; as is a road or railway or line of trees extending straight ahead to the horizon. The sky in a sunset picture may also best occupy more than the top two-thirds of the photo, given that the bottom of the picture will be silhouetted and will lack detail. There are also similar compositional rules which can sometimes work more

effectively than the 'rule of thirds', such as the so-called 'Golden Ratio', which measures the grid-lines slightly differently based on the mathematics of the 'Fibonacci sequence', or the 'Golden Spiral' or the 'Golden Triangle'. If you are using the crop tool in Adobe Lightroom to process your photos, try repeatedly hitting the 'O' key. This will offer you a choice of different compositional overlays – see which works best.

The rule about subjects needing space to move into can also sometimes be worth breaking. If your subjects are moving out of the frame this can evoke a sense of motion, or curiosity as to what they are leaving behind. Even horizons don't always have to be absolutely horizontal. Tilting the horizon can add extra dynamism to some photos and, for instance, add a sense of motion or speed or chaos. The tilted horizon line can also help lead the eye to your subject. However, any tilt less than 15 per cent can look like an accident! Equally, midday photography can sometimes be very effective, if, for instance, you want small sharp shadows and want to evoke a harsher and colder mood or if you are shooting in black and white and need plenty of contrast.

None of this is meant to suggest that the rules of photography are unnecessary – simply that it's worth breaking or bending them once in a while, if they are not to become unhelpful dogmas. Some photographers distil the rules into a single one. For instance: 'fill the frame with what you like'[2] or 'without the right light, you don't have a photo … take this saying and make it your bible'[3] or 'there are no rules for good photographs, there are only good photographs'.[4]

People also embrace rules as part of their spirituality. For instance, the ten commandments may be taken as a guide to ethical living: have no other gods; have no graven images or likenesses; do not take the Lord's name in vain; remember the sabbath day; honour your father and your mother; do not kill; do not commit adultery; do not steal; do not bear false witness; do not covet.[5] Jesus distilled them into two main commandments: 'Hear, O Israel: The Lord our God, the Lord is one. And you shall love the Lord your God with all your heart and with all your soul and with all your mind and with all your strength'. and 'You shall love your neighbour as yourself.'[6] He also summed up the Old Testament Law and Prophets in the words of the so-called 'Golden Rule', which appears with minor variations in all major world religions: 'in everything do to others as you would have them do to you'.[7]

But sometimes it may be necessary to break a rule. For instance, if you had been sheltering Jewish refugees during the Second World War, it might have been necessary for you to lie in order to hide their presence from Nazi soldiers. Sometimes it's more important to obey the spirit, rather than the strict letter, of religious rules. Grace becomes more important than law. Being a good person is more than simply keeping a set of rules. We recognise truly good people by their overall character and the consistency of their attitudes and behaviour. Goodness becomes habitual and second nature to such people. They have been shaped by 'things which are holy and right and pure and beautiful and good'.[8]

Taking a lead from people who belong to religious orders, some people find it helpful to have a personal

'rule of life' to which they commit. The word 'rule' derives from the Latin word 'regula', from which we also get the words 'regulate' and 'regular'. A rule of life is a gentle framework that helps to regulate our life and give it shape and direction, much like a trellis helps plants to grow securely. As the Christian spiritual writer, Marjorie J. Thompson, points out: 'When it comes to spiritual growth, human beings are much like … plants. We need structure and support … We need structure in order to have enough space, air, and light to flourish. Structure gives us the freedom to grow as we are meant to.'[9]

Creating your own rule of life can help you live more purposively and enable you to clarify your 'most important values, relationships, dreams and work'.[10] One way of doing this, suggested by the Canadian *Society of Saint John the Evangelist* (SSJE) in their Lent 2016 *Growing a Rule of Life* programme, is to reflect, in turn, on your relationship with God, your relationship with self, your relationship with others, and your relationship with creation. Then consider what simple, realistic steps you can take to nurture these relationships and what spiritual practices might be helpful. SSJE offers a 'Tool Shed' of different practices, including, for example, 'swim laps focusing on a different song of praise or intercessory prayer on each lap' or 'visit an elderly person each week who is shut-in at home or in a nursing home' or 'compost food at home each day and give thanks for the fertile waste', as well as more traditional spiritual practices'.[11] It's important to create your own rule of life, rather than simply borrowing someone else's. Ideally, it should be neither too ambitious nor too vague.

 USING YOUR CAMERA PHONE
If you want some help in achieving aesthetically pleasing photos, you might want to experiment with some composition overlays. These will affect the image you see when taking your photo, but will not be visible on the final picture. For instance, you might want to take account of the 'Rule of Thirds'. A 'thirds' grid can be selected on an iPhone or iPad (Settings/Photos and Camera/Grid). Other overlays, such as 'Golden Ratio' and 'Golden Triangle', are available via apps such as 'Camera Awesome'[12] (iOS and Android).

There are also apps available to help ensure key areas of your photos are sharply in focus, such as 'Focus – RAW Manual Camera with Smart Focus Peaking'[13] (iOS) – those parts of the image that are in sharp focus are highlighted on the LCD screen in bold colour by this app.

Your challenge

Try keeping and then intentionally breaking some rules of photography.

Take a photo of plants growing with the help of a trellis or other support. Create or fine tune your own 'rule of life', naming the spiritual practices that could shape you in future.

My challenge notes

New discoveries about my photography ...

New discoveries about myself and my spirituality ...

Things to explore more ...

What I will try differently in future ...

My photo that best expresses my journey of discovery in this chapter ...

You are invited to
print out one of your photos
and place it here

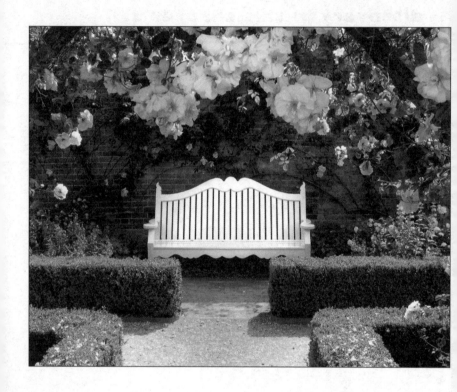

CRITICISM

It's nice to have your photos admired. Friends and family can be very positive about your photos – sometimes because they genuinely appreciate the images, sometimes out of politeness and loyalty. Photos that you post on social media can attract plenty of 'likes', but this may not be a true indication of how good the photos actually are. What would a neutral unbiased person say about your photos? One solution is to make sure that you have some brutally honest friends. Another would be to join a camera group and enter their photo competitions, judged by independent external judges. A good judge will be candid, while accenting the positive features of your photos and making constructive suggestions as to how the images might be improved.

No judge is perfect, however. Each is likely to have particular preoccupations. For instance, one judge may be very keen on cropping out extraneous details, another may be keen on incorporating human interest, another may always look for odd numbers of subjects, another may prefer perfectly symmetrical images to be disturbed by one item out of place, and so on. The same photo may be evaluated differently by different judges.

Similarly, there are fads and fashions in photography which can mean that the same photo may be seen as cutting edge or highly fashionable for a time and

then, later, be perceived as rather passé. For example, currently, flowing water is usually depicted very softly. The water in a fountain, waterfall, river or seashore is often shown as very 'milky' and smooth. Individual droplets, splashes and rivulets are not visible, thanks to especially long exposures, often necessitating the use of a tripod and sometimes a 'neutral density' filter to help prolong the exposure. This may, or may not, be a passing fad. Some might argue that the energy of moving water is better captured with a shorter exposure and crisper image. Another current example is 'High Dynamic Range' (HDR) photography. HDR images widen the range of tones in an image, beyond what most camera sensors can achieve, potentially making the image more like what was seen by the human eye. A high contrast image, without HDR, can easily suffer too white, blown-out highlights or, alternatively, too black, undetailed shadows. An HDR image, combining several shots with different exposures, can bring out all these details. However, photographers often have a love-hate attitude to HDR. Too much HDR can make a photo look rather garish and contrived and even somewhat surreal!

Landscape photography offers another example of changing trends. Back in the nineteenth century, landscape photographers tended either to evoke a rural idyll, as an antidote to rampant industrialisation, or, especially in the USA, to depict vast, soaring, though humanly tamed, wildernesses. Currently, the trend is for very bleak, gritty scenes, though many still prefer softer, calmer and more serene images. Some

photographers prefer to exclude all signs of human activity from their landscapes. Most are happy to include walls, fences and railways, but some draw the line at pylons and wind turbines and plastic-wrapped hay bales. Wiltshire landscape photographer, Ken Leslie, prefers images without direct traces of human presence. He claims that his most sellable photos include a wilder, undomesticated, more elemental dimension plus some 'sunshine'. However, if there is too much 'sunshine', he says, it becomes just a predictable 'calendar-style' image.[1]

Judgements may change as to whether or not a photo is 'beautiful' – at different times and places – although there do seem to be some aspects of beauty that are universally recognised, such as balance, proportionality and symmetry. A good judge or critical friend will not be too swayed by the latest fads and fashions and will help you see the best features of your photos and how they might be improved.

It's worth having some wise, robust and constructive critics in your life. They can offer you reality checks and help you steer in the direction you most want. The best critics will help prevent you from being either too harsh on yourself or blind to your own shortcomings. Sometimes you can find good critics in the groups to which you belong, especially spiritually based groups. The early Methodists, for instance, used to exercise mutual care for each other. Early Methodist small groups, known as 'classes', used to confess their sins to each other and urge one another to repentance and spiritual growth. They spoke of 'watching over one

another in love'.[2] This phrase was most likely inspired by two verses from the New Testament: 'speaking the truth in love, we must grow up in every way into him who is the head, into Christ'[3] and 'let the word of Christ dwell in you richly; teach and admonish one another in all wisdom'.[4] Sometimes we can only discover the truth about ourselves from people who we have come to respect for their resilience, wisdom and plain speaking. They are generally people who show personal stability, who are neither 'blown here and there by every wind of teaching'[5] nor followers of every passing fad and fashion.

Some people get a special critic to help them understand and steer their life. These critics go under various names, such as 'Soul Friend' or 'Spiritual Director' or 'Holy Listener' or 'Spiritual Life Coach'. It's best if they don't act like film critics, who can be brutally savage. Instead, their criticism is ideally perceptive, supportive, compassionate and honest. They may or may not be 'critical *friends*' – sometimes there needs to be a greater degree of critical distance. Alan Jones, then Dean of Grace Cathedral, San Francisco, once described the most desirable qualities of such a person: 'She would need to be grounded in ordinary everyday experience ... earthy and have the ability to see the funny side of the spiritual enterprise even in the midst of great suffering ... crafty – wily enough to spot the byzantine ploys of the ego to make itself the centre of everything, even of its own suffering and struggle ... able to make judgments without being judgmental, to smell a rat without allowing her ability to discern

deception sour her vision of the glory and joy that is everyone's birth-right in God'.[6]

Good, timely, well-focused criticism can help enhance both your photography and your living – if you are willing to have proper humility, to accept constructive criticism, and have proper pride, to accept due praise and affirmation.

 Using your camera phone

Apps are available that claim to be able to identify automatically your 'best' photos, such as 'The Roll'[7] (iOS and projected for Android) – its developers claim that this app 'combines the artistic principles in photography with deep learning technology. This learns and replicates the choices of professional curators and applies them to your photos.'[8]

Online critical feedback from other people is available from a site such as '1X Photo Critique'[9] – where you can submit your own images for review and provide critique to others. Flickr has a 'Critique' section, with a mission to help members 'empower other members in a respectful and supportive way'.[10] 'Professional Photo Critique' offers the chance to dialogue with professional, academically trained critics, who, it is claimed, will identify strengths and weaknesses of your pictures in a 'diplomatic and encouraging way'.[11]

There is also an online robot 'personal photo coach' called 'Keegan',[12] which bases its critical feedback on automatic image analysis.

You might want to experiment with one of the current fashions in photography – 'High Dynamic Range' (HDR) images. You may find this is already an option on your camera or you might need to install an app, such as 'True HDR'[13] (iOS) or 'HDR Camera'[14] (Android), which will also offer you greater control over the HDR image.

Your challenge

Try to get expert criticism of some of your 'best' photos – why not join a camera group and enter their competitions? Watch for the improvements in your photography.

Remember and cherish the constructive criticism and praise you receive from others. Consider having a Soul Friend or Spiritual Director.

My challenge notes

New discoveries about my photography ...

New discoveries about myself and my spirituality ...

Things to explore more ...

What I will try differently in future ...

My photo that best expresses my journey of discovery in this chapter ...

You are invited to
print out one of your photos
and place it here

THE ORDINARY AND EVERYDAY

Some people only take photos when they're away from home. They prefer to photograph somewhere unfamiliar and apparently much more attractive than where they live ordinarily – unless, of course, they already happen to live in an especially beautiful place. And so, apart from taking pictures of family occasions, their photography may be reserved for beautiful, pretty or exotic subjects far afield. If they're photographing natural scenery they may capture, say, a picturesque, 'chocolate-box' image or, alternatively, a more awesome image of vastness and terrifying drops. If you wanted to take either of these types of image you too might not find them in your immediate neighbourhood. However, this doesn't necessarily mean that there is nothing worth photographing nearer to home. If you endlessly regret the fact that you don't live in a truly beautiful place you may end up missing fascinating photographic subjects right in front of you.

Just because an area is over-familiar to you doesn't mean that your photos are going to be uninteresting to others. And, intriguingly, you may notice things that you have previously overlooked in your photos of familiar places. Try starting by imagining you are showing someone new to your area what are the most

interesting features of your neighbourhood. Try to look at your neighbourhood with fresh eyes. What are the key buildings and landmarks? What are the key stories in its history and its present? What signs are there of the changes that have happened and are still happening to the area? What drew you to the area in the first place? What makes it feel like 'home'? What makes this a similar place to other places and what makes it a place like no other? If you live in a truly boring place and there really is nothing to photograph, gradually look further afield, maybe to where you work or somewhere within easy travel distance of home. It's unlikely you will have to look far, once you begin to look with fresh interest and curiosity.

Taking photos of the ordinary and everyday gives you time and opportunity to experiment with different genres of photography. For instance, you may want to have a go at street photography, or still-life photography, or macro (close-up) photography – perhaps of flowers in your own garden, or architecture photography, or night photography, or even social documentary photography (maybe focusing on things that need changing in your society) – it depends what subject matter captures your interest. There are several advantages to photographing in your locality. You will have essential local knowledge and access to others who can top up your local knowledge. You will be able to choose when you take your photos, at the best time of day and the best time of year or, deliberately, at various times of day and different seasons. A visitor to your neighbourhood, by comparison, may only get one chance, at possibly a less photogenic day

or time. After you review the photos you take, you will be able to revisit the location of your photos, to maybe re-frame your images, take them from another vantage point, or adjust the settings on your camera.

Photographing the ordinary and everyday can help you ground your spirituality in what happens each day in familiar places. It can actively help you notice glimpses of God in the ordinary. Sometimes we think that God can only be experienced in the extraordinary, the supremely beautiful, or the awesomely sublime – special rare moments that rarely punctuate our boring everyday lives. Those special experiences are important aspects of spirituality, but only part of its overall rhythm. Most religions periodically offer times and places of intensified experience of the holy, in major festivals and big gatherings, but also help their followers 'come back to earth' and worship God in their day to day lives. Photographing the ordinary can help us survive those gaps between our spiritual highs and make us more aware of holiness around us. Like the poet, Gerard Manley Hopkins (1844–89), we can start to see the world as 'charged with the grandeur of God' and recognise that 'there lives the dearest freshness deep down things'.[1] We can catch glimpses in our everyday lives of the God in whom 'we live and move and have our being'.[2] We can take more notice of everyday epiphanies – such as signs of kindness, hope and creativity. As a prayer in The Methodist Worship Book asks: 'in the midst of our everyday lives surprise us with glimpses of the glorious, humble love at the heart of existence'.[3]

Jean-Pierre de Caussade, a French Jesuit writer (1675–1751), used to speak of 'the sacrament of the present moment', of God's presence in the smallest as well as the greatest events of our lives: 'The present moment holds infinite riches beyond your wildest dreams but you will only enjoy them to the extent of your faith and love. The more a soul loves, the more it longs, the more it hopes, the more it finds. The will of God is manifest in each moment, an immense ocean which the heart only fathoms in so far as it overflows with faith, trust, and love.'[4] 'To discover God in the smallest and most ordinary things, as well as in the greatest, is to possess a rare and sublime faith. To find contentment in the present moment is to relish and adore the divine will in the succession of all the things to be done and suffered which make up the duty to the present moment.'[5]

A young London office worker reflected recently on photography's capacity to re-engage us with the sacrament of the present moment: 'Today I realised how beautiful the frost is making everything look and the clear early morning January sunlight you can see out of my office window is actually amazing. I know with certainty that, for the past few weeks, I have been completely ignoring it in favour of reading the news and dwelling on all the worrying things happening at the moment, desperately wanting to change things and not knowing how. Then I thought to myself that, unlike me, a photographer may have been noticing all this and taking good pictures.'[6]

 USING YOUR CAMERA PHONE
Camera phones can be tools for experimenting with different genres of photography. They are ideal for unobtrusive street photography. You can be taking pictures while appearing to check your phone. Be careful though not to impinge on people's privacy. If possible, ask their permission to take the photo (or keep the photo, if you've already taken it). 'Burst' mode on your camera phone can be useful here, as it enables you to take a quick succession of photos. By its very nature, street photography tries to capture something that is fast moving. Perfect poses, facial expressions, strides or interactions can be over before you get a chance to press the shutter. If you take a burst of, say, 50 shots, the chances are that at least one will be suitable. On the iPhone all you need to do is to lock your focus and exposure (by pressing the screen for three seconds) and then keep your finger on the shutter button until you've taken a long enough burst of photos (at 10 frames per second).

Macro images can be captured on a camera phone with a suitable additional macro lens, such as the Camkix 'Universal 3 in 1 Lens Kit'[7] (iOS and Android) or the Olloclip '4-in-1 lens'[8] (iOS and for some Android devices). Remember to take compatibility into account: some lenses will

work on many different devices, but others only fit certain camera phones. Use a tripod, if at all possible, as even small fluctuations in the camera phone's distance from the subject will affect the focus.

Night photography involves techniques similar to sunrise/sunset photography (see pp. 32 – 40). Ideally, it's worth taking manual control of your camera phone, to use as low an ISO value as possible. The ISO setting regulates the sensitivity of the camera phone's image sensor. Opting for low ISO will minimise unwanted random 'noise' in your pictures. However, it will also increase the length of the exposure. Most night photography will involve relatively lengthy shutter speeds and will need a tripod of some kind. It's true that some camera phones, such as the iPhone 7 Plus, offer image stabilisation (optical/digital/hybrid), but you may find this is not enough for night photography purposes.

It is also worth taking 'ordinary and everyday' pictures in the so-called 'golden hour' for added warmth and (if the sun is out) long soft shadows. An app such as 'Golden Hour'[9] (iOS and Android) will enable you to find out the exact time of the golden hours at your location on any given day. There are two golden hours each day: the first starts just before sunrise and the second finishes just after sunset.

Your challenge

Imagine you are showing your neighbourhood to someone new. Try photographing what you would show them.

Keep your eyes open for glimpses of God in the smallest and most ordinary things.

My challenge notes

New discoveries about my photography ...

New discoveries about myself and my spirituality ...

Things to explore more ...

What I will try differently in future ...

My photo that best expresses my journey of discovery in this chapter ...

You are invited to
print out one of your photos
and place it here

TRUTH TELLING

It's often said that 'the camera never lies', although most people understand that photos can be enhanced or faked. If they stop to think about it, rightly or wrongly, few people expect fashion shots to look just as they came out of the camera, blemishes and all. On the other hand, most would invest more trust in documentary photos or photojournalism and make the assumption that such pictures should not have been altered or manipulated.

The advent of digital photography has made it easier to alter images post-production and has made us more suspicious about photographic images. Previously, in chemically based photography, light had travelled through the camera lens and left a footprint, as it were, on light-sensitive film. Digital cameras simply convert an image into numerical data. However, this doesn't necessarily mean that pre-digital photography was more trustworthy, simply that photo alteration took place in the chemical darkroom rather than the 'computer darkroom' of Photoshop,[1] Lightroom,[2] Picasa,[3] or the like. For instance, in the mid-nineteenth century photographic film was ultra-sensitive to violet and blue and this meant that, in otherwise correctly exposed photos, skies often appeared washed out. Landscape photographers overcame this problem by taking two

images, one capturing the sky and the other capturing the land, which they later combined in the darkroom. Sometimes the original clouds were inserted, but, equally, other clouds were sometimes added for greater dramatic effect.

There is a world of difference between, on the one hand, post-production devoted to increasing the effectiveness of an image and, on the other hand, post-production intent on fundamentally manipulating an image away from how it originally looked. If you have access to any post-production software, you will probably want to make some adjustments to your digital images to optimise how they look, unless you are totally happy with how they appear when they are initially downloaded from your camera. Often, the camera may not have captured the image in quite the way you remember it and, in order to retrieve some of the original impact, you may decide to do some post-production enhancement. A few tweaks to the image's brightness, contrast, colour temperature, hue and saturation, and 'levels', for example, may restore what originally drew you to this image. However, it's easy to over-do such alterations and end up with something that looks blatantly artificial! It's worth making changes incrementally; on the basis that 'less is more'.

Post-production that involves extensive manipulation of an image can be relatively uncontroversial. If you are treating photography as an art form, for instance, you may want to fabricate an image, which like any other work of art, may or may not resemble anything actually existing in the real world. You might decide to combine

images from different parts of the world, for example, to produce a composite image or you might decide to produce a surrealistic fantasy world. However, ethically speaking, it's best to be upfront about what you've done, in order to prevent any confusion. Other types of extensive post-production of images can be much more controversial and can amount to fakery and deception. Famously, *National Geographic* digitally moved two of the Pyramids of Giza to fit the front page of the magazine in February 1982.[4] Nowadays the magazine will only accept RAW format, demonstrably unaltered, images for publication.

After the January 2015 *Charlie Hebdo* terrorist attacks, the ultra-Orthodox Israeli newspaper, *HaMevaser*, published an image of world leaders walking in solidarity through the streets of Paris. However, all the female leaders had been digitally removed from the image, to avoid offending the paper's readers.[5] This was not an accurate portrayal of the event, although the picture appeared in the paper without any further explanation. Similarly, families have been known to digitally remove people from family celebration photos after conflict or divorce, to make it look as if they were never present. Less controversial, perhaps, is when deceased people are added to family photos, such as a father who tragically dies before their child is born. Sometimes, when this is done, the image of the dead person is deliberately overlaid semi-transparently, so that viewers do not get confused.

Post-production adjustment of photos can be harnessed for truth-telling or for deception. You may

find yourself treading a fine line between the two. It is important to recognise which you are doing and to make this clear to viewers, if you are to act with integrity.

When your camera takes JPEG images, as most amateur cameras do most of the time, the camera compresses the image to take up less storage space. In the process it makes some decisions on your behalf about how the image will look and jettisons some of the original visual data. If you want more control over your images and to stand a greater chance of rescuing poorly exposed photos, you will probably choose to shoot in RAW format, if your camera has this facility. But this will mean that your photos can't be downloaded fully fledged from the camera: you will need to spend time afterwards adjusting the RAW image in post-production software, such as Photoshop. Valerie K. Isenhower suggests that you need to do something similar spiritually if you are going to process properly 'the unworked data of the photographic experience in [your] hearts'.[6] It's important to spend time at the end of a day's photography reflecting on how it has affected your spiritual journey, asking questions such as: 'What did I learn about myself today?' and 'How has today helped me grow closer to God?'[7] It's worth doing this before, rather than after, you apply any post-production to your photos, to get you into a good frame of mind for doing post-production.

In your own spiritual journey you may not always be what you seem to be. Others may not get the full picture. Sometimes you may enhance or fake your

identity to impress others or fool yourself. But role playing can be a perfectly proper part of your life. As Shakespeare put it: 'All the world's a stage, and all the men and women merely players; they have their exits and their entrances, and one man in his time plays many parts.'[8] Often these may be roles you need to grow into, such as if and when you become a brother or sister or aunt or uncle for the first time. Sometimes the roles you aspire to may just be delusional, if, for instance, you start thinking of yourself as some kind of superhero. Equally, sometimes there are roles that can actively make us better people – the true self you most want to be. Famously, John Wesley relates in his *Journal* how in the months before his 1738 conversion he had become very despondent about his own lack of faith. 'It struck into my mind, "Leave off preaching. How can you preach to others, who have not faith yourself?"' He spoke to his Moravian friend Peter Bohler about this, who advised him not to give up preaching. 'But what can I preach?' Wesley asked. Bohler said: 'Preach faith till you have it; and then, because you have it, you will preach faith.'[9] This was amongst the best advice John Wesley ever received. For a while he was merely role-playing as a person of faith, but eventually this brought him to a vibrant, personally owned faith. Sometimes you can re-picture and re-imagine your life for the better, though you are likely to find wise critics and the resources of faith communities more helpful in this than Photoshop!

 Using your camera phone

It's worth being aware that your camera phone, like all cameras, will do some auto enhancement of your images (for instance, by adjusting sharpness, colour and contrast), unless you are able to tell it to shoot in RAW (or RAW and JPEG). This isn't necessarily a problem, if you are happy with the pictures that your camera phone produces, but shooting in RAW and JPEG would give you the maximum chance of rescuing a photo that has, say, incorrect exposure or an unwelcome colour cast.

If you want to enhance images taken on your camera phone, try using a post-production app, such as 'Adobe Photoshop Lightroom'[10] (iOS and Android), 'Adobe Photoshop Express'[11] (iOS, Android and Windows) or 'Snapseed'[12] (iOS and Android). Apps such as these enable you to enhance your photos there and then on your camera phone, without having to transfer them to your main computer. 'Adobe Photoshop Lightroom' will edit RAW files, as well as JPEG (devices running iOS 10 and above).

Your challenge

Make a copy of a photo with special meaning for you. Work on the copy using post-production software and try to recapture more of the image's original impact.

How might you re-picture and re-imagine your life for the better?

My challenge notes

New discoveries about my photography ...

New discoveries about myself and my spirituality ...

Things to explore more ...

What I will try differently in future ...

My photo that best expresses my journey of discovery in this chapter ...

You are invited to
print out one of your photos
and place it here

PERSONAL THEMES

Some people simply take photos of anything and everything, but many of us have common themes running through our photography. This may take the form of common subjects that we return to over and over again. Equally, we may have developed our own style of photography, which others may already have noticed, even if we haven't recognised it yet. You may already be aware of the subject matter that you are most frequently drawn to. If not, try looking back at the photos you have taken during the last year – laying them out on the floor, if they have been printed, or working through them on screen, if you only have digital copies. See if you can group them together into recurring themes. If you are doing this on the computer, you may wish to copy the files and work with the copies, rather than risk mixing up the original files. Look for sub-themes as well as over-arching themes. Global themes can be a little too unspecific. For instance, your global common theme might be 'nature', but your particular fascination might be with, say, 'nature reclaiming urban wastelands' or 'ancient trees in modern environments'. If you look back far enough you may find your common themes evolving, but try to identify the common threads running through your images.

You may also be able to pin down your particular style: for instance, what colours tend to dominate your

photos, where do you tend to place your main subject, do you prefer landscape or portrait orientation, does your composition favour sweeping circles or straight diagonals? This exercise might be done on a dark winter evening, when it's too cold to be out photographing, with the help of someone else who can lend you their perspective too. Once you are aware of your recurring themes, you should be more confident about what you want to photograph, even in an entirely new location.

When the photographer, Andrea Moffatt, from the Little Story Studio, Greensburg, Pennsylvania, reviewed her images, she noticed that one of her overarching themes was pictures of her children being 'passionately curious'. She wrote: 'As I comb through my images, I find shot after shot that shows my children experiencing the senses of curiosity and wonder. Not only that, but I also come across a great many shots that show my own curiosity. For example, I'll find a series of my kids doing something, and right in the middle of the story, there will be an image of the steam from my coffee cup or an interesting shadow'. Reflecting on why she is drawn to taking such photos, she suggests that they powerfully encapsulate one of her core values and a key aspiration for her children: that of curiosity. She believes that 'curious people will lead meaningful, passionate lives ... that curious people are inherently interested in the lives and plight of others ... curious people ask questions, seek answers, and above all – listen' and that 'being passionately curious is akin to being in love with the world and the people in it'. 'Because I believe these things,' she says, 'I am drawn to shoot it ... when I see it, I click, I can't help myself'.[1] Identifying

common themes in your photography can sometimes help you see yourself and your core beliefs more clearly.

As part of their spirituality some people practise a regular review, or 'Examen', of each day. This involves re-playing the day to re-experience it and notice what stands out. This may recover positive experiences, evoking feelings of joy and wonder, or difficult ones that carry a sense of struggle, temptation or hurt. They may then form the basis of prayer.

The seventeenth-century priest, poet and spiritual writer George Herbert gives this advice in his poem 'The Church Porch':

> Sum up at night, what thou hast done by day;
> And in the morning, what thou hast to do.
> Dress and undress thy soul: mark the decay
> And growth of it: if with thy watch, that too
> Be down, then wind up both; since we shall be
> Most surely judg'd, make thy accounts agree.[2]

The Examen can also be a means of discovering and developing your understanding of what has been called your unique 'sealed orders' – a single word or phrase 'naming' who you are – 'as if, before we were born, each of us talked over with God the special purpose of our time on earth' and 'throughout our lives each of us discover more and more deeply our unique sealed orders, a way that only we are gifted to give and receive love'.[3] The Examen can also be applied to longer periods of time, such as a whole year. Reviewing the photos you have taken during the past year could be a helpful part of such an examen.

You may find that the recurring themes in your photography give you new insight into your unique identity and your core values. They may also provide a fresh way to share with others, in picture-language, the things that matter to you. The Church Army's 'Faith Pictures' course suggests that each person's unique story and its underlying themes can be crystallised into a 'faith picture' – an image or metaphor that can be 'a powerful way to communicate our own unique relationship with God, as well as the aspects of God's character we most appreciate and identify with'. One of the videos in the course contains clips of individuals describing their 'faith pictures', which include: a stone mason; a roller coaster; tapestry; abseiling; a battered old Land Rover; a brown banana; a Duracell bunny; a steep winding road; an assault course; fire; the AA; a hand; a comfy shoe; a water bottle; glue; and a man with hiccups.[4] As 'Faith Pictures' points out, discovering our own 'faith picture' can make it 'easy and natural to talk about what we believe'.[5]

Perhaps the common themes in your photography already reflect your 'faith picture'. If not, you might further develop your 'faith picture' by deliberately creating photos that reflect it. This can apply to anything we want to cultivate in ourselves. For instance, as the Christian spiritual writer, Christine Valters Paintner, observes, our photography can reflect and reveal fresh aspects of a virtue that we seek, such as patience: 'if we discover the beauty in a snail moving ever so slowly across the earth, that moment of image can remain in us as a powerful reflection of what we seek in our own lives'.[6] The themes of our life and the themes of our photography can powerfully inspire each other.

Using your camera phone

 One way of recognising trends in your photography is to look at the photos stored on your camera phone in date-order. There will normally be a way of grouping your photos sequentially according to the day, week, month or year in which they were taken. Try reviewing the photos you have taken in the last twelve months. Then compare them with the images you took in the previous twelve months and notice if any particular themes begin to stand out.

You could also group photos together differently in your camera album – for instance, those which have similar subject matter or reflect similar photographic genres. Individual photos or batches of photos can also be tagged as you start to see common features. You may find it easier to copy your photos to a desktop or laptop to do this. In the Pictures Library in Windows you simply select the picture(s) you want to tag, right click and then add and save a tag in the details pane that opens at the foot of the page. It is then possible to call up all the photos to which you have given a particular tag, by simply using the search box in your Pictures Library or Windows Explorer.

Your challenge

Review the photos you have taken in the last year. What are the common themes?

Try to identify your own 'faith picture'. How might you illustrate and cultivate this in your photography?

My challenge notes

New discoveries about my photography ...

New discoveries about myself and my spirituality ...

Things to explore more ...

What I will try differently in future ...

My photo that best expresses my journey of discovery in this chapter ...

You are invited to
print out one of your photos
and place it here

A PHOTOGRAPHER'S PRAYER

In a world wrapped in darkness
Where people yearn for sight
Where good and evil fight
You are the light

You are the light of the world
The light that makes everything shine
The light that enhances and warms and then treasures
And even makes the mundane look divine

Thank you for creation and beauty
Thank you for gifts and passion and skills
Thank you for nature and people and pleasure
Thank you for dance and mountains and hills

Flow through me with your spirit
Help me see the beauty you see
Help me capture in one instant moment
Your goodness, God, let my image reveal.

May my image build up and not tear down
Enhance and not detract

Encourage and strengthen, feed and enrich
Challenge, inspire, impact.

For there is a battle from which we cannot retire
Between all that is good – and hell and its fire
To create images that move you to fight
To give yourself, to that I aspire

I want to take pictures that point out the nature of evil
I want to take photos that point out the horrors of war
I want to give hope and move people to action
For goodness, redemption of the broken and poor

May I as your image reflect your glory
May your kindness shine through my face
May I take pictures that tell your story
As I walk in your light and your grace.[1]

© Rogier Bos 2007 – reproduced by permission

What next?

This book is just a taster, to whet your appetite. There are plenty more ways for photography and spirituality to inspire each other. Keep on exploring – this is just the beginning!

NOTES

Introduction and invitation

1 'Annals of my Glass House', 1874, The Royal Photographic Society Collection at National Media Museum, 2003-5001/4/22511.

2 'The Elixir' (1633), John Tobin, ed., *George Herbert: The Complete English Poems*, London: Penguin, 2004, 174.

3 R. Watson and K. Trickett, eds, *Companion to Hymns and Psalms*, Peterborough: Methodist Publishing House, 1988, 454

4 Philip Sheldrake, 'Is spirituality a passing trend?', OUPblog, 23/11/12, http://blog.oup.com/2012/11/is-spirituality-a-passing-trend/ (accessed 27/1/17)

From snaps to slow photography

1 Ephesians 1:18

2 https://www.rijksmuseum.nl/en/startdrawing

3 Kosuke Koyama, *Three Mile an Hour God*, London: SCM, 1979, 7

4 Luke 10:38–42

5 'Kneeling' from R. S. Thomas, *Not that he brought flowers*, London: Hart-Davis, 1968, 32

6 https://fotr.co/

Framing

1 www.adobe.com/photoshop

2 https://itunes.apple.com/gb/app/snapseed/id439438619?mt=8; https://play.google.com/store/apps/details?id=com.niksoftware.snapseed&hl=en_GB

3 Luke 6:20

4 Acts 3:1–11

5 *The Connexion*, 4/2016, 2

Sunrise

1 Proverbs 4:18

2 2 Samuel 23:3b–4

3 Matthew 16:2–3

4 Thomas Traherne (1636–74) – Denise Inge, ed., *Thomas Traherne: Poetry and Prose*, London: SPCK, 2002, 4.

5 John Keble (1792–1866), 'New every morning is the love' (hymn).
6 Eleanor Farjeon (1881–1965), from the hymn, 'Morning has broken'.
7 Tomáš Halík, *Night of the Confessor: Christian faith in an age of uncertainty*, New York: Image Books, 2012, 176.
8 http://joby.com/griptight-gorillapod-stand
9 http://shootmanual.co/
10 http://www.camerafv5.com/
11 http://truehdr.com/
12 https://play.google.com/store/apps/details?id=com.almalence.hdr
13 http://sunriseandfall.com/
14 http://app.golden-hour.com/

Perspective

1 https://www.nationalgallery.org.uk/paintings/carlo-crivelli-the-annunciation-with-saint-emidius
2 Matthew 6:21
3 Timothy Rees (1874–1939'), 'God is Love' (hymn)
4 Arthur Campbell Ainger (1841–1919), 'God is working his purpose out' (hymn)
5 http://appm1.com/afterfocus/
6 http://www.juicybitssoftware.com/
7 www.kula3d.com/

Telling a story

1 'Migrant Mother' – https://www.moma.org/collection/works/50989
2 http://www.barbican.org.uk/strangeaudio/photographs/paul-strand/
3 http://www.worldpressphoto.org/collection
4 'The Elephant's Child' (1902) – Rudyard Kipling, *Just So Stories*, Ware: Wordsworth Editions, 1993, 50.
5 http://www.picturecorrect.com/tips/make-sure-your-photographs-tell-a-story/
6 Helmut Gernsheim and Alison Gernshei, *A Concise History of Photography*, London: Thames & Hudson, 1965, 166.
7 Images by Cameron are available at: http://www.geh.org/ne/mismi3/cameron_idx00001.html
8 Dennis Morris, *Easter Images*, Diocese of London & CMS, 2008.
9 http://churchmissionsociety.org/our-stories/shooting-jesus
10 http://www.joachimfroese.com/species.html
11 http://www.theblurb.com.au/Issue59/Froese.htm (accessed 3 April 2016)
12 https://itunes.apple.com/gb/app/after-photo-add-caption-text/id640032822?mt=8; https://play.google.com/store/apps/

details?id=com.tinilab.afterphoto&hl=en_GB
13 https://itunes.apple.com/gb/app/font-candy-photo-editor-add/
id661971496?mt=8; https://www.microsoft.com/en-gb/store/p/
font-candy-typography-photo-editor/9nblgggzmqsp
14 https://www.instagram.com/
15 http://photo365app.com/
16 https://play.google.com/store/apps/details?id=pl.pawelbialecki.
a365photoapp&hl=en_GB
17 http://365project.org/

Mist and fog

1 Isaiah 44:22
2 Wisdom of Solomon 2:4
3 Mark 9:7
4 Exodus 19:9
5 Kallistos Ware, *The Orthodox Way*, Crestwood: St Vladimir's
Seminary Press, 1995, 13–14.
6 https://itunes.apple.com/gb/app/snapseed/id439438619?mt=8;
https://play.google.com/store/apps/details?id=com.niksoftware.
snapseed&hl=en_GB

Breaking the rules

1 Haje Jan Kamps, *The Rules of Photography and When to Break Them*,
Lewes: Ilex, 2012, 164.
2 Joshua Cripps, https://www.professionalphototips.com/2015/02/
create-better-compositions-important-rule-photography/
3 Mark Yap, http://www.examiner.com/article/the-most-important-
rule-you-can-learn-photography (accessed 5 March 2016)
4 Ansel Adams, quote attributed to Adams by E. T. Schoch, *The
Everything Digital Photography Book*, Avon MA: Adams Media,
2002, 105.
5 Exodus 20:1–17; Deuteronomy 5:6–21
6 Mark 12:29–31
7 Matthew 7:12
8 Philippians 4:8 (*J. B. Phillips New Testament*)
9 Marjorie J. Thompson, *Soul Feast*, Louisville, Kentucky:
Westminster John Knox Press, 1995, 145.
10 'Facilitator's Guide', *Growing a Rule of Life*, Cambridge,
Massachusetts: SSJE, 7 – www.ssje.org/2016_growruleresources/
GrowRule_FacilitatorsGuide.docx
11 'Facilitator's Guide', 41
12 http://www.cameraawesome.com/
13 http://www.klingerstudios.com/focus/

Criticism
1 Private conversation
2 John Wesley's *General Rules*, 1743
3 Ephesians 4:15
4 Colossians 3:16
5 Ephesians 4:14 (NIV)
6 Margaret Guenther, *Holy Listening: The Art of Spiritual Direction*, Plymouth A Cowley Publications, 1992, Preface.
7 http://theroll.eyeem.com/
8 https://www.eyeem.com/blog/2016/05/the-roll-our-new-ios-app-to-organize-find-your-best-photos/
9 https://1x.com/critique#!/critique
10 https://www.flickr.com/groups/critique/
11 http://www.professionalphotocritique.org/mission-statemen/
12 https://keegan.regaind.io
13 http://truehdr.com/
14 https://play.google.com/store/apps/details?id=com.almalence.hdr

The ordinary and everyday
1 'God's Grandeur' (1877) in W. H. Gardner, ed., *Gerard Manley Hopkins: Poems and Prose*, London: Penguin, 1985, 27.
2 Acts 17:28
3 *The Methodist Worship Book*, Peterborough: Methodist Publishing House, 1999, 132.
4 Jean-Pierre de Caussade, *The Sacrament of the Present Moment*, New York: HarperCollins, 1989, 62.
5 *The Sacrament of the Present Moment*, New York: HarperCollins, 1989, 64.
6 Claire Rakich, private correspondence.
7 http://camkix.com/product/camkix-universal-3-in-1-cell-phone-camera-lens-kit-fish-eye-lens-2-in-1-macro-lens-wide-angle-lens-universal-clip-black/
8 https://www.olloclip.com/shop/lenses/iphone6-4-in-1
9 http://app.golden-hour.com/

Truth telling
1 www.adobe.com/photoshop
2 www.adobe.com/lightroom
3 https://picasa.google.co.uk/
4 http://www.alteredimagesbdc.org/#/national-geographic/
5 http://www.nytimes.com/2015/01/14/world/newspaper-in-israel-scrubs-women-from-a-photo-of-paris-unity-rally.html?&_r=0
6 Valerie K. Isenhower, *Meditation on Both Sides of the Camera: A spiritual journey in photography*, Nashville, TN: Upper Room Books, 2012, ebook loc. 1491.

7 loc. 1560.
8 *As You Like It*, Act 2, Scene 7.
9 John Wesley's *Journal*, 4 March 1738.
10 http://www.adobe.com/uk/products/lightroom-mobile.html
11 http://www.photoshop.com/products/photoshopexpress
12 https://itunes.apple.com/gb/app/snapseed/id439438619?mt=8;
 https://play.google.com/store/apps/details?id=com.niksoftware.
 snapseed&hl=en_GB

Personal themes

1 Andrea Moffatt, 'Photo Personality: Finding Themes Within
 Your Work', http://fearlessandframed.com/discovering-photo-
 personality-finding-themes-within-your-work/
2 'The Church Porch' in *The Temple* (1633) – *George Herbert: The
 Country Parson, The Temple*, Mahwah, NJ: Paulist Press, 1981, 121ff.
3 Dennis Linn, Sheila Fabricant Linn and Matthew Linn, *Sleeping
 with Bread: Holding what gives you life*, Mahwah, NJ: Paulist Press,
 1995, 20–1.
4 http://media.2144.churchinsight.com.s3.amazonaws.com/
 e581104e-7540-42bc-bb58-ccab4d9f5ee9.mp4
5 http://www.churcharmy.org.uk/Groups/266914/Church_Army/ms/
 Faith_Pictures/Sessions/Sessions.aspx, Leader's Notes, Session 4
6 Christine V. Paintner, *Eyes of the Heart: Photography as a Christian
 contemplative practice*, Notre Dame, Indiana: Sorin Books, 2013,
 101.

A photographer's prayer

1 http://ourjourney.typepad.com/the_journey/2007/12/a-
 photographers.html